Coloring
Mandalas
for Meditation

Fair Winds Press
100 Cummings Center, Suite 406L
Beverly, MA 01915

fairwindspress.com • bodymindbeautyhealth.com

Coloring
Mandalas
for Meditation

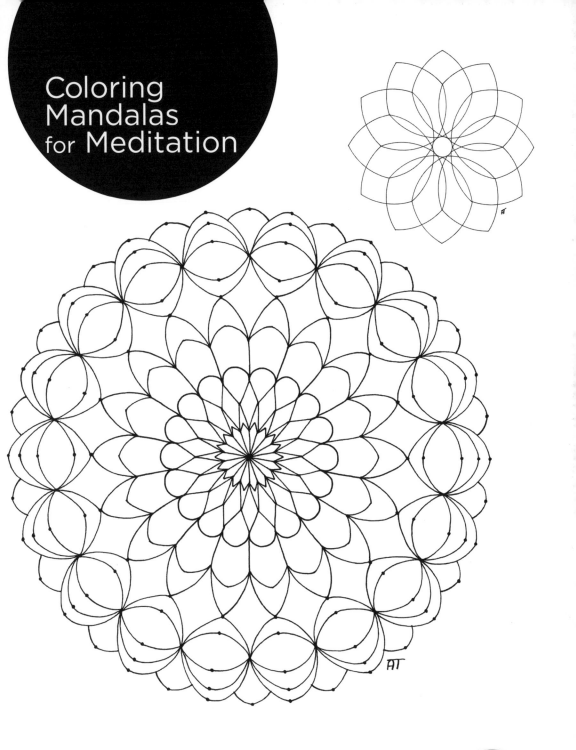

Armelle
Troyon

© 2012 Éditions de La Martinière une marque de La Martinière group, Paris

First published in the USA in 2014 by
Fair Winds Press, a member of
Quarto Publishing Group USA Inc.
100 Cummings Center
Suite 406-L
Beverly, MA 01915-6101
www.fairwindspress.com
Visit www.bodymindbeautyhealth.com. It's your personal guide to a happy, healthy,
and extraordinary life!

18 17 16 15 2 3 4 5

ISBN: 978-1-59233-655-5

Cover design by Quarto Publishing Group USA Inc.
Book design by Sur Mesure, Fabienne Chesnais

Printed and bound in China

Contents

Did You Say "Mandala"?

Mandala is a word from India. In sanskrit, it means circle, or more precisely, a thought within a circle. Some people think that this means a mandala is just a drawing within a circle, but it is more than that. A true mandala has a center that the eye is immediately drawn to. If the center is too big, the eye doesn't know where to look and will choose a detail from the surrounding image such as an animal's eye or the heart of a flower, which in many cases is away from the center. The focal point of a mandala centers the mind. This is why coloring a mandala that does not have a strong central point can be unsettling.

What Is a Mandala?

A mandala is a patterned drawing with a well-defined center surrounded by a periphery. Most of the time that periphery is round, but it can take any other shape: square, rectangle, hexagon, or even a non-specific shape. As well as other drawings and forms around the center, we always find a circle within the mandala.

Mandala is a very lovely word and is easy to remember, so it is the word most often used when talking about this form. However, we could equally talk about "centered drawings" or "rose-shaped drawings" because mandalas can be found in every culture on Earth. The rose windows of European cathedrals are magnificent examples of mandalas, where the rose form is often used in ornamentation and decoration.

Our ancestors used to build their villages following a structure very close to that of a mandala: at the center we find the village square with all the streets running away from that area to a surrounding boundary wall. Some people also use the mandala form for their houses; for instance, American Indian tepees, Mongolian yurts, Eskimo igloos, and African huts. All of these are round buildings with a hearth at their center. Friends and family sit in a circle around the fire, the source of light and heat.

The mandala is also a universal shape found everywhere in the natural world. If you take a fruit or a vegetable (an orange, apple, carrot, zucchini) and cut a cross section, you see a magnificent mandala. Look at flowers, cobwebs, sea-urchins, starfish, water molecules, and human cells—when you start looking, you see all of nature is organized around this form. Even our solar system is a giant mandala.

What Does This Form Give Us?

If you take the two most characteristic parts of the mandala and you compare them to a human cell or a village, it is very easy to see the importance of the center and the periphery.

In the center of the human cell, there is a nucleus containing our DNA where we find most of the cell's information. In the village, the central square is the place people go to revitalize themselves, meet with the elders to hear their opinions, or to get advice. The village center is also most often where we would find the site of a place of worship. In fruit, it is at the center that you find the seeds or the nucleus, the resources the fruit needs to reproduce.

The periphery stands for security. It is the cell's membrane that prevents things from entering the cytoplasm. Around the village, the boundary wall protects the villagers from invaders; in the evening, the doors are closed and the inhabitants are safe. As for fruits and vegetables, they are surrounded by the skin that ensures the protection of the inner flesh.

Symbolically, the center represents the site of inner resources and the periphery represents protection. When we are in a mandala we are in touch with our deepest being while also feeling safe and protected.

Children instantly respond to the vitality of the mandala form and immediately recognize that its core is fundamental to our being. When they are around eight years old and discover how to use compasses or a Spirograph, they have fun drawing patterns over and over again. This is because these patterns are mandalas, geometric, and artistic in equal measure. Children respond to the form of the mandala intuitively because they sense it helps them build themselves and get in touch with their deepest identity. Around the age of seven, children begin to lose their naivety as they begin to be able to reason. Children become aware of themselves as unique beings with different personalities and desires, beginning to assert themselves and being self-aware. Mandalas can help children during this process of change.

Why Use Mandalas for Meditation?

Nowadays, we talk a lot about the benefits of meditation, and there are many books on the topic. But what is meditation? For some it is about staying still, being silent, and examining our inner selves. For others, it is about achieving a different state of consciousness or profound relaxation, or about having insight into the connectedness of the world.

Many people think that meditation is simply sitting in silence in the lotus position or on a chair with a straight back. For others, meditation can happen at any time: walking, peeling vegetables, doing the daily chores...

I won't try and give you a new version of meditation; I am only suggesting you look for your own version of meditation to suit what your needs could be:

- Freeing yourself from the constant stream-of-consciousness
- Developing your attention-span and your focus
- Being fully in the present moment
- Being aware of your body, your sensations, and your feelings
- Finding peace and quiet within yourself
- Rediscovering what matters most to you
- Rediscovering yourself
- Emptying your mind
- Moving toward inner peace

It is important for everybody to find the form of meditation that suits them best. Do you prefer sitting still or do you prefer to be in motion? Do you like music in the background or do you need something to focus your attention on? The only thing that matters is finding out what is right for you. Tibetan monks use the lotus position to meditate; but long ago in the abbeys, monks used to walk around the cloisters in order to pray and meditate.

In this book, I suggest you use mandalas in order to find a new way of meditating. Use coloring as an activity that allows you to find yourself and develop your spiritual identity. After all, isn't that what we all want?

To find our axis, discover what animates our life, and see that the source of happiness and peace isn't outside us, but exists within us as a superior intelligence, a confidence, a security, and a wisdom. The modern world takes us away from these things, with its constant pressures and materialism, which tends to make us believe that the more we possess, the happier we are. Deep down we know that the opposite is true and that by returning to simplicity we can find a source of pleasure and joy.

How Will Mandalas Help with Meditation?

In my first book, *Coloring Mandalas for Peace* I showed that coloring a mandala is a very good way to calm your thoughts and find peace. We become caught in the harmony of the moment as we apply different colors and see our own mandala take shape before our eyes. Each and every one of us is unique and if you give the same mandala to one hundred different people, you will get back one hundred different mandalas.

These mandalas I have created for meditation have been conceived with simplicity and uniqueness in mind. Each one of them has a deliberately small number of motifs and forms, geometric or otherwise. However, the motif at the periphery is also very often at the center, because that is the aim of meditation: to be brought back to the center of yourself, of your sensations and your feelings.

Some mandalas contain a twisting motion which also allows you to recenter yourself, while spiral patterns remind us of childhood and the discovery of Spirographs, allowing us to create that harmonious form.

By giving you these mandalas to color, I offer you a means of finding a childlike pleasure in choosing and arranging colors without having to ask yourself any questions.

Most of these mandalas are simple so that coloring them will bring you back to your essential being. Thanks to their form and their organization, you will develop your focus and your attention span. That, after all, is what meditation is about: being attentive to our essential inner thoughts and feelings, not constantly responding to the visual or audio stimuli of our modern world.

Being aware of yourself and being able to accept the world for what it is without wanting to change it: this is the state of mind that we aim to achieve through meditation.

There are two plains in a mandala:

•The Horizontal Plain: consisting of a center, a pattern around that center and a periphery. Remember, if you cut a fruit or a vegetable in slices (orange, tomato, carrot, zucchini, etc.) you will see a mandala. The cobweb, the solar system, water molecules, human cells are all mandalas.

Symbolically, the center of the mandala represents the nucleus of the human cell and brings us back to the first cell that multiplied. In that nucleus is our DNA with everything that constitutes us. Coloring a mandala provides us permanent contact with that center, that nucleus.

The periphery also has an important role. It provides security: if you take our slice of orange, it is the peel that takes a protective role. At the center, the seeds, or nucleus, ensure reproduction. In the human cell, the cell membrane at the periphery prevents intruders from entering the cytoplasm and also plays a protective role.

Being able to recenter, being in touch with your most profound resources while being safe, is what mandalas can bring you. Coloring these mandalas is a meditative act that will bring you toward your core because the motifs at the periphery can also be found at the center. This horizontal plain represents the material plain: the drawings, the forms, and the colors, which will be all about your inner being because you will have chosen them and they will match your interior state at that moment.

- **The Vertical Plain,** with an axis that goes through the center of the mandala. This vertical plain allows all your different levels to interact while you color the mandala. Your physical, emotional, mental and spiritual levels will vibrate together. Some people experience a true moment of spirituality when coloring their first mandala, a unique moment of encountering themselves, finding the answer to an essential question, finding a moment of inner security, while at the same time experiencing a state of quietness and focus.

We return to the definition of meditation: meditation is a deep thought that applies focus to a particular subject (in this specific case, yourself).

Meditation usually implies that the practitioner focuses his or her attention in a circular fashion on one point of reference, the center.

Some authors who write about meditation feel it is necessary to explain what meditation isn't, and I also feel that this is helpful. Some practitioners believe that meditation means disconnecting entirely from the physical world. However, our physical senses and being present in our bodies is essential to meditation. Our spirituality must be lived on a daily basis. We live in a material world and escaping this fact is not helpful in achieving a more fulfilled existence. On the contrary, finding an alliance between the two worlds, bringing them to life at the same time is what brings joy and a sense of self-realization. Mandalas are very beautiful instruments for use in finding that balance.

Using Mandalas for Balance and Rejuvenation

We have two cerebral hemispheres and they work in completely different ways.

- **The Left Brain** is the mental hemisphere. It sees everything in detail, wants to explain everything, rationalize everything. It is the side that handles space, time, and speech. It is also the side that processes rules and laws. It is the side for action, for doing, and is the side used in the world of work and school. It is the side that modern society focuses on. We could say that the Left Brain is our "adult brain," the one that we develop over the years.

- **The Right Brain** perceives things globally. It is the hemisphere of the senses, of imagination, creativity, intuition, and inspiration. Where the Left Brain is specific, the Right Brain is general. We tend to forget about the Right Brain in the world of work, but it is just as essential that we keep using it in order to rejuvenate ourselves. Personal interests and hobbies use the Right Brain. It is the "child's brain" that we all keep within ourselves..

Neither of the hemispheres is "better" than the other. However, going back and forth between the two—using the Left Brain at work for handling day to day chores, using the Right Brain for enjoying life and rejuvenating yourself—is not a good solution because it causes fatigue or even exhaustion. The ideal situation is to have both sides working together, putting creativity and imagination into work and daily chores while being connected to our intuition and imagination. The key for achieving balance and rejuvenation is finding hobbies that allow us to use both sides of our brain, using our creativity and imagination while being anchored in reality and structure: walking in a forest or on the seafront, building a sand castle, climbing trees, dancing, playing a musical instrument, and so on.

Living day-to-day while using both the Left Brain and the Right Brain, is the key to finding inner joy along with security and balance in your axis.

Mandalas help you to find this balance. By choosing colors, you are expressing your creativity, your intuition, and your senses (the Right Brain). As you color each motif and each detail, you handle space and use logic and deduction (the Left Brain). You use both sides of your brain at the same time, hence the feeling of balance.

To be linked to a spiritual axis while being in the material world: this is one way of defining *meditation*.

Very few activities use both sides of our brain at the same time. Doing activities that achieve this balance allows us to find new connections and recover the energy of the side that is less used on a daily basis.

Creating Mandalas for Meditation

All the mandalas I present in this book are drawn by hand. Creating a mandala with a computer application is very easy: one click and you can reproduce the chosen motif as many times as necessary. However, such reproductions will result in perfectly identical forms, which will therefore be unnatural. In the natural world, every element is unique: if you pick a hundred roses they will all be different. In the same way, each human being is unique. A mandala drawn on the computer is not alive; it is mechanical, and its "perfection" leads to the false idea that perfection is possible.

When I draw a mandala, first I make an outline: with a pencil I trace several concentric circles. I then use a protractor to draw diameters and radii, varying their number. Most of the time, I leave this to chance.

I then think about the project that I have chosen. The project is actually very important and you should also think about it before you color. If you choose to color a mandala to decorate a child's room, your approach won't be the same as if you are choosing to meditate or release yourself from a stress or an emotion.

In order to create the mandalas in this book, I thought about meditation and the forms and motifs came to me. Sometimes I would just wake up in the morning with a mandala before my eyes. I soon realized that in creating mandalas for meditation, I was only using one, two, or three motifs every time. Also, in general, the designs are very simple. In some of them, you will find movement, a motion turning from the outside toward the inside, suggesting the path you will take to lead you back to your inner self.

After designing the outline, I then trace the motifs with a pencil. I sometimes use tracing paper, a ruler, or compasses. If you look at them closely, you will see that these mandalas are not regular; you will see them come to life, each motif having its own unique form.

Finally, I go over the entire drawing with black felt-tip pen and erase the outline, even though its effect remains underneath. Even when they are not perfectly symmetrical, good mandalas have to be built upon a structure and have a certain pattern. Similarly, the eye must spot the center right away.

Who Are These Mandalas For?

Some think that meditation is only for adults. On the contrary, I think that it is important for everyone, even for children. You don't necessarily need to give the activity that specific name. Isn't it important for each and every one of us, however old we are, to stop, find their inner silence and balance, to be in touch with simplicity and security?

Coloring mandalas is actually a great activity to do as a whole family, with everybody around the same table but in their own personal space. Just because you are together does not mean that you always have to be talking.

This can be a very good occasion for children to learn how to appreciate silence, a stillness that is hard to find in our modern lives. Coloring mandalas together is a way of learning another mode of communication: sharing a single activity. After working together on a mandala, everyone can, if they wish, talk about the mandala, what has been achieved, or how they felt during the activity.

How Long Does Coloring a Mandala Take?

Many adults are scared to begin coloring mandalas because they think it will take too much of their time. But you don't have to finish coloring a mandala all in one sitting! Coloring for five or ten minutes is enough to calm yourself down, to relax, to re-energize yourself so that you can be more efficient afterwards. If you give it a go, you will be surprised to see that in only a few minutes, you are fully absorbed by what you're doing and able to block out the pressures of life around you.

People sometimes tell me that they are too busy and always have something else to do. I advise them to try allocating ten minutes a day for one week. In that time, the benefits and sense of calm they feel are so great that soon the desire to color mandalas comes to them quite naturally

In our daily lives, there are many occasions when we find ourselves waiting for something. If you take your mandala book with you, it will help you pass the time while waiting for a bus or for a doctor's appointment. Coloring will result in you not being as upset about waiting as it will be a chance to recenter yourself and relax.

As much as possible, do try to finish one mandala entirely before you start a new one. This is even more important for children. On the other hand, there are no rules when it comes to meditation. If you start a mandala, but then don't like what you have chosen by the time you return to it, by all means choose another one. Pleasure is the most important thing about the process

You don't have to be by yourself to color a mandala because the act of coloring will create a bubble around you. In fact, coloring a mandala can often be the best way to encourage other family members to also begin the activity. Children often imitate behaviors where they would not obey an order

How to Choose and Color a Mandala

There are absolutely no rules. Don't do the mandalas in the order they appear in this book; follow your heart and listen to your intuition. Ask yourself, "Which one appeals to me today?" It doesn't matter if you think a mandala is too complicated or too easy. Depending on the day, our needs are different. Why shouldn't an adult color a very simple mandala? Very young children can also choose very detailed mandalas. Unlike the adults, who feel compelled to color every little detail, children often color by zone without caring about the little motifs.

When it comes to mandalas, no one is judging.

Really, does the result matter that much? When you meditate with something other than mandalas there is no tangible proof of the result. Isn't the experience you went through a hundred times more important than the result itself? Have you gone over the lines in some places? It doesn't matter! This moment of meditation must no be evaluated; you can even throw away the mandala once colored. Or, put it in a frame on the wall! Judgements and evaluations are a large part of our society: it's up to you to transform that moment of coloring into something different without aiming for a specific result.

Once you've chosen your mandala with your intuition and your heart, do the same with the colors. It doesn't matter if you use felt-tip pens, pencils, paint, or

pastels. Spread out all the colors in front of you and let yourself be drawn to them. Your body knows exactly what it needs.

If you are tired, it will guide you toward bright colors to energize you; likewise, if you need to calm down, you will be drawn to soft colors. Trust yourself and, most of all, don't try to follow somebody else's example. The mandalas are here to take you to yourself.

Success is found in the quality of the moment you experience, not in the aesthetic results of the mandala you create. If you are still struggling to detach yourself from the idea of a material outcome, think about yoga or meditation: if you had just been to a session, you would have nothing physical to show for it. Ephemeral mandalas created by Tibetan monks with colored sand are beautiful examples of letting go of possessions. Indeed, these monks can spend many hours with other monks crafting their mandalas, before blowing them away to give them back to the universe.

Meditation and Mandalas

Peace, simplicity, self-reflection, spirituality, and lightness… While discovering the benefits of meditation, you will understand it is not a moment when you shut yourself off from the world. You will also feel that it represents the opposite of the daily routine where you doing things mechanically and out of habit.

To meditate, is to listen to yourself and to your feelings, to be balanced and connected to your inner-force and your senses at the same time.

Coloring a mandala is one of the paths you can take in order to enter a period of meditation; a door that opens to freedom and pleasure. The freedom to be what you are, the pleasure of finding the inner-child within you that simply wants to express itself. I wish you a beautiful journey in the world of meditation and mandalas.

200 Mandalas for Coloring

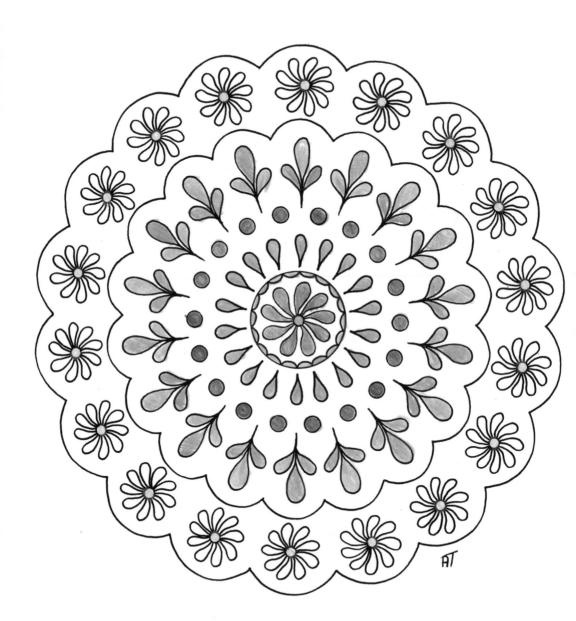

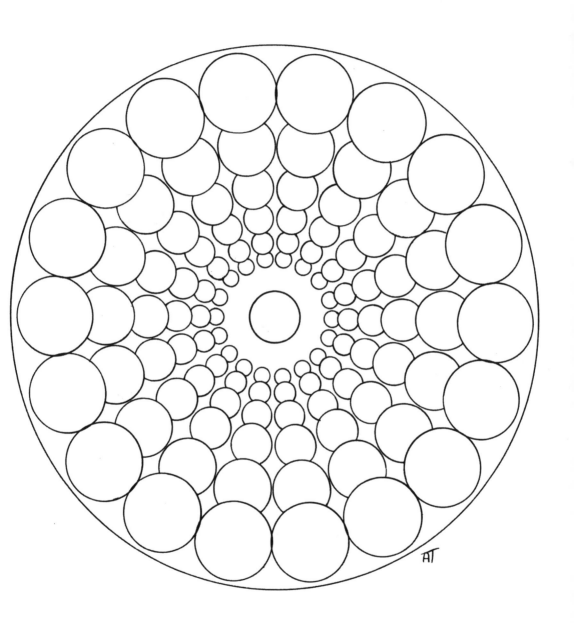

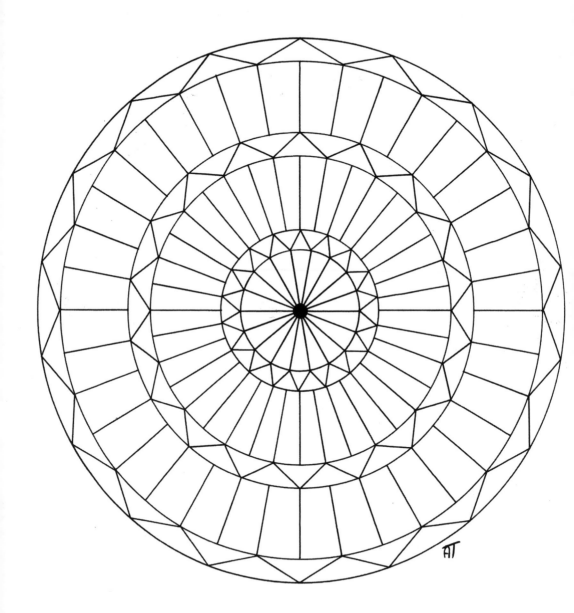

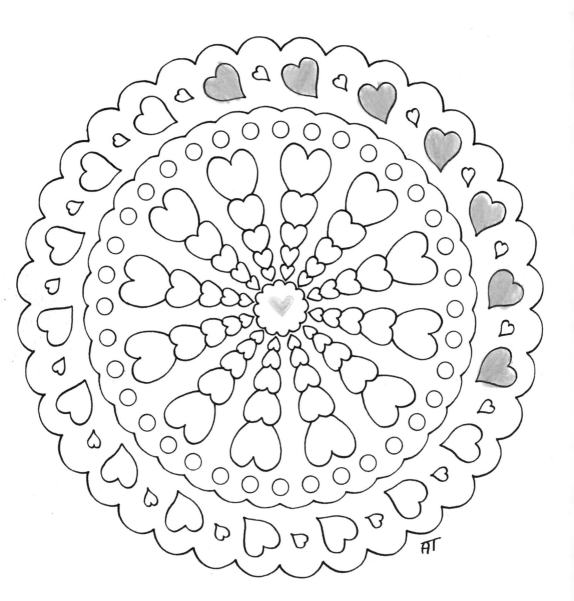

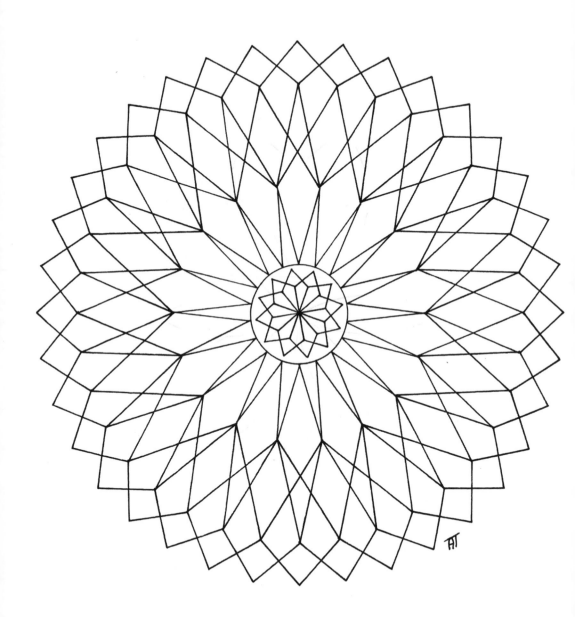

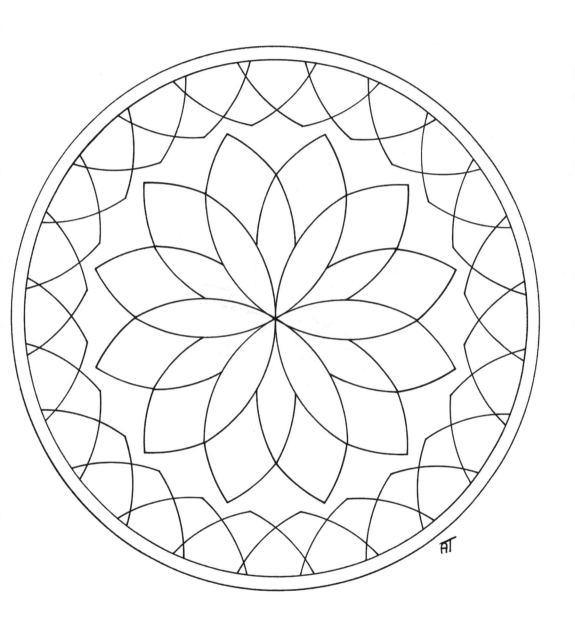

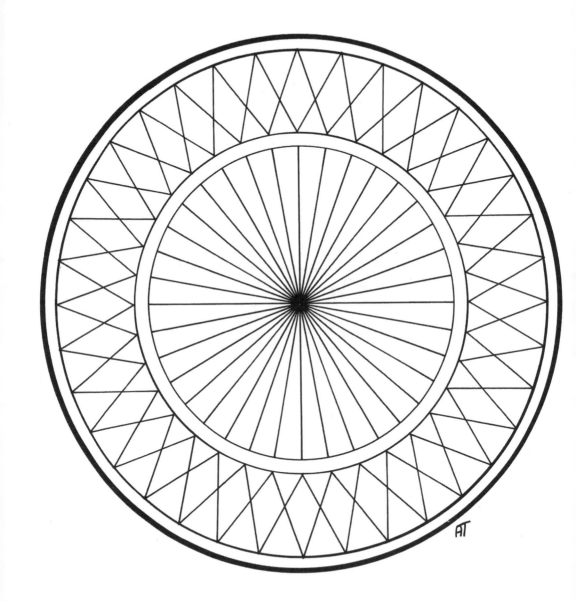

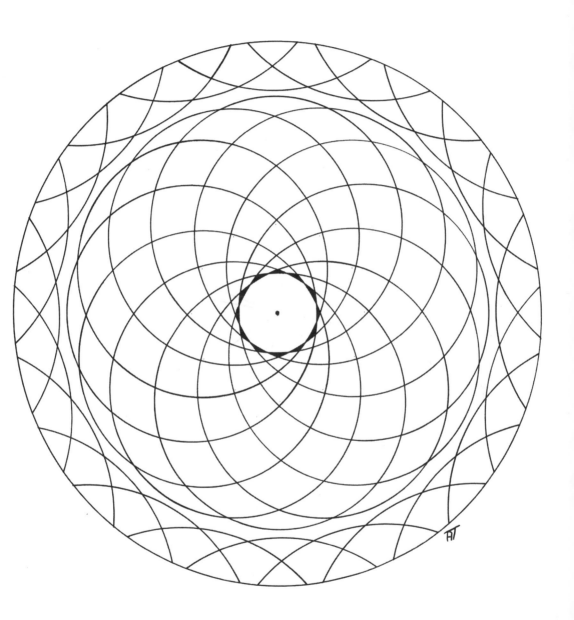

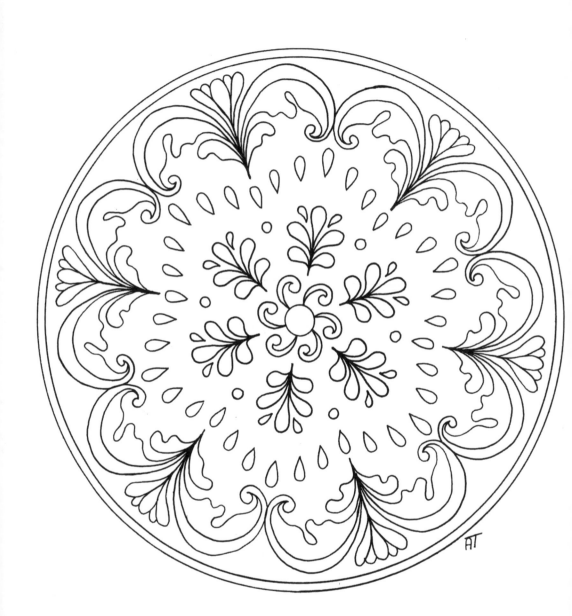

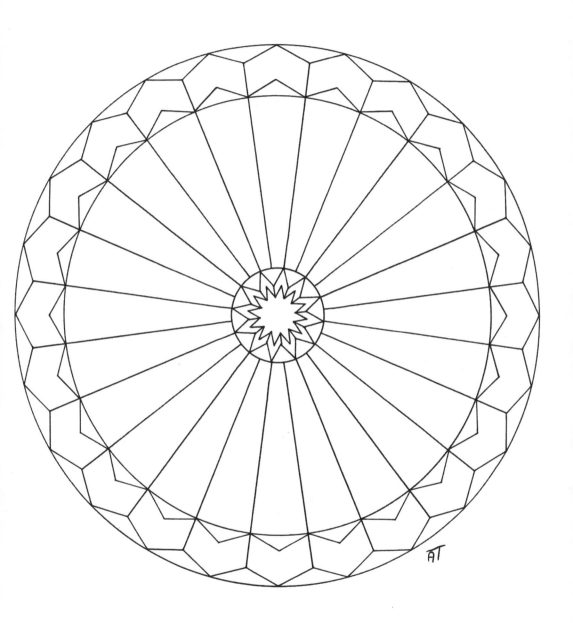

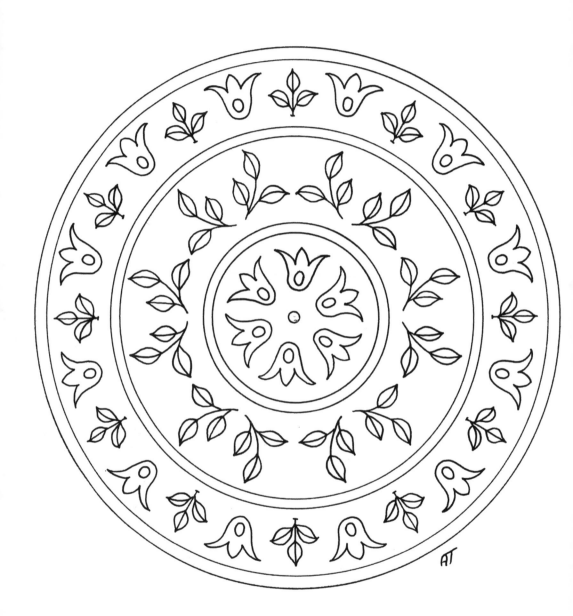

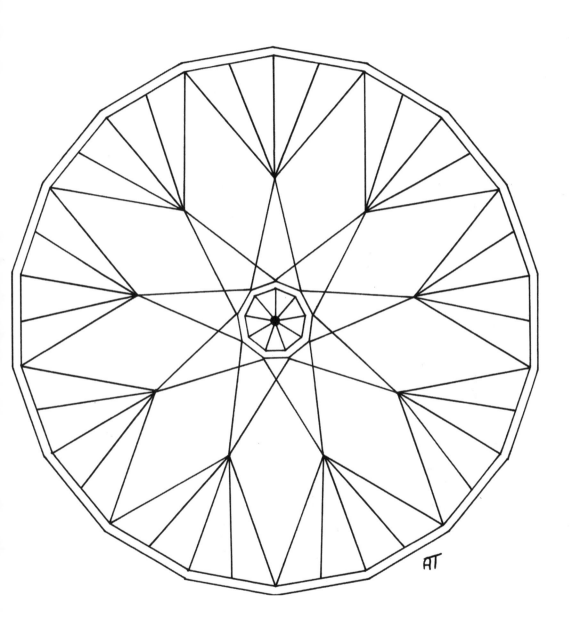

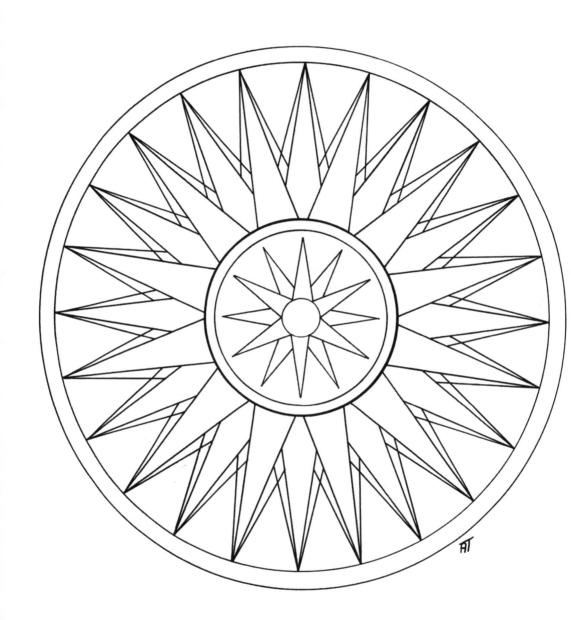

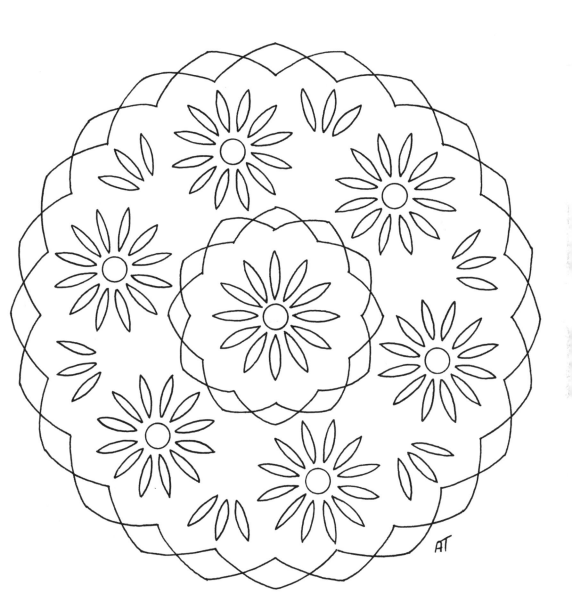

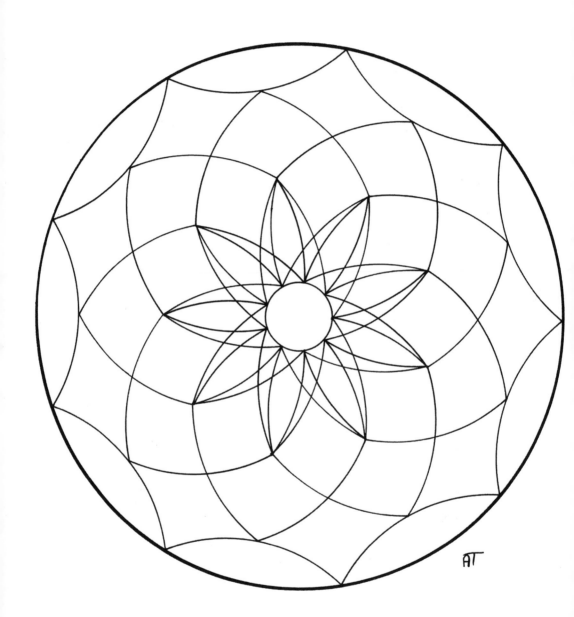

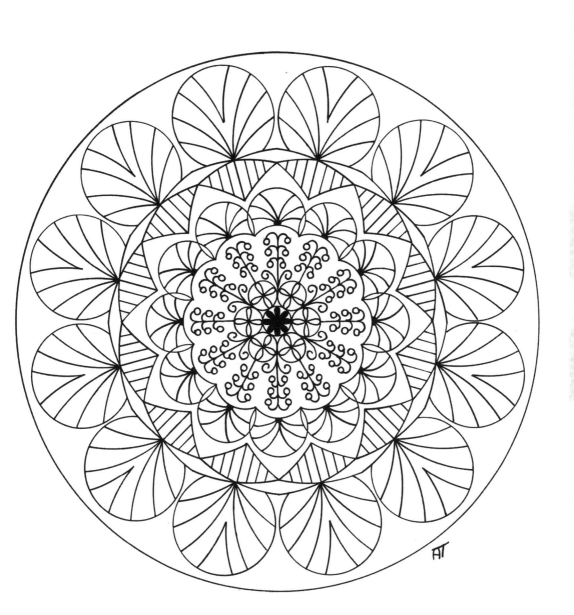

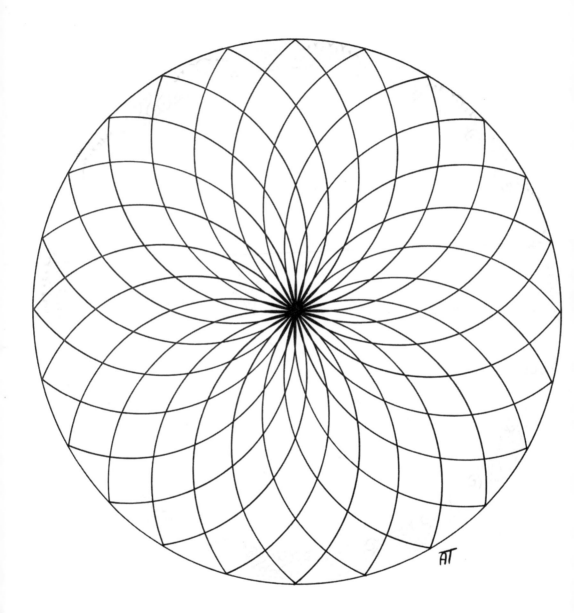

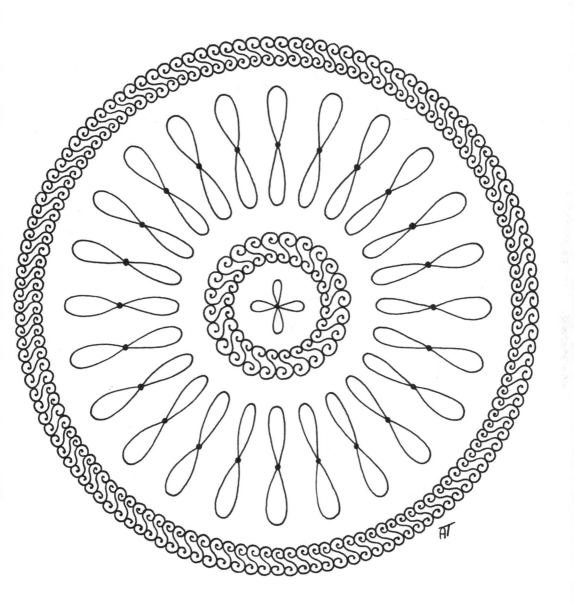

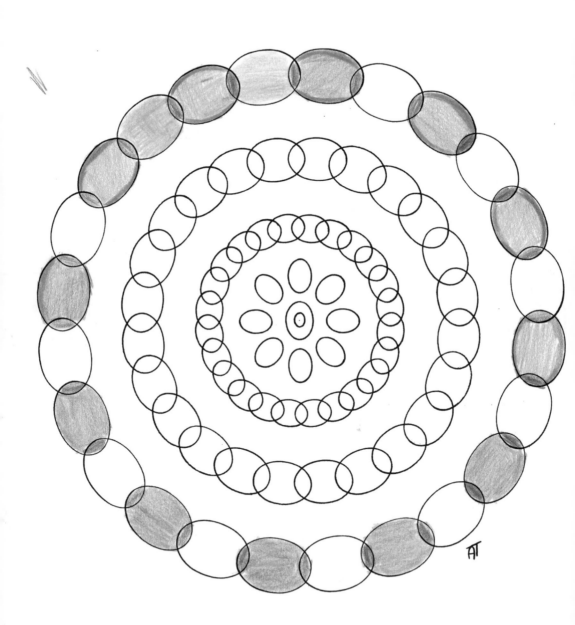

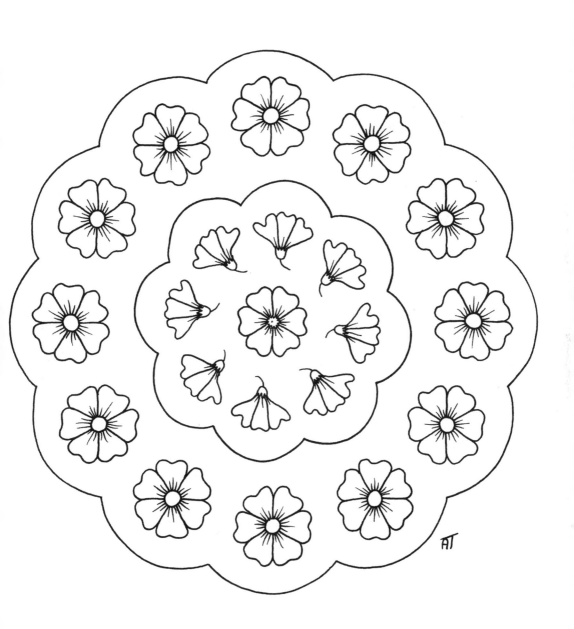

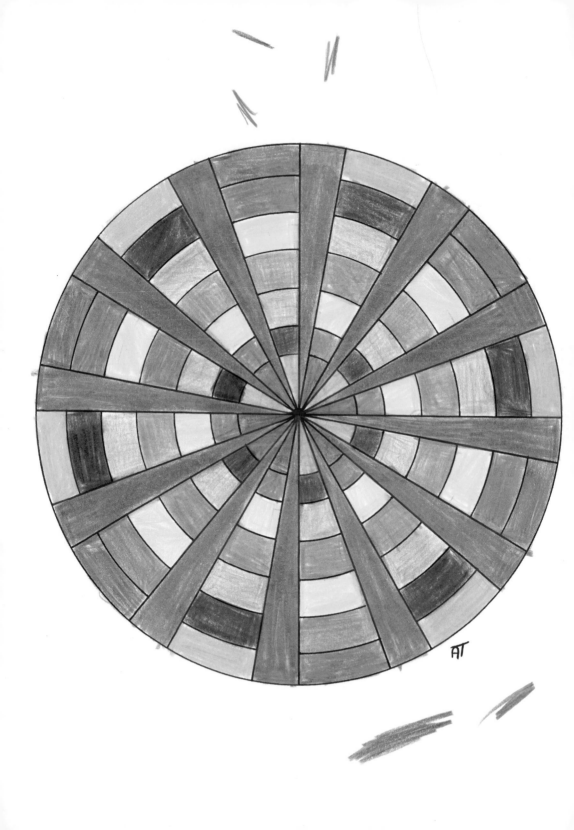

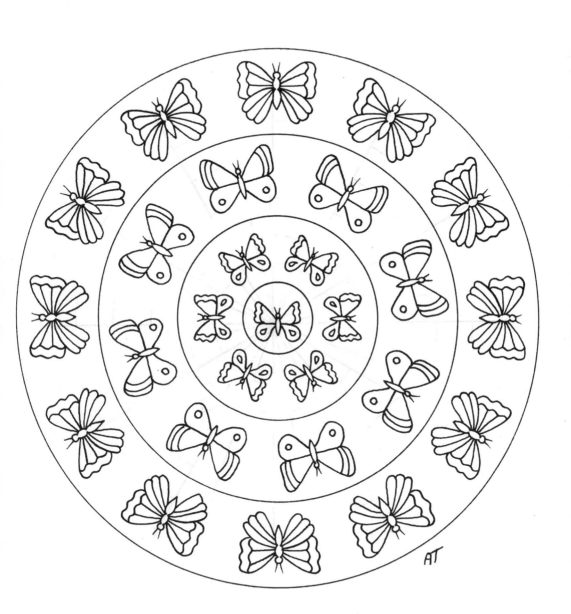

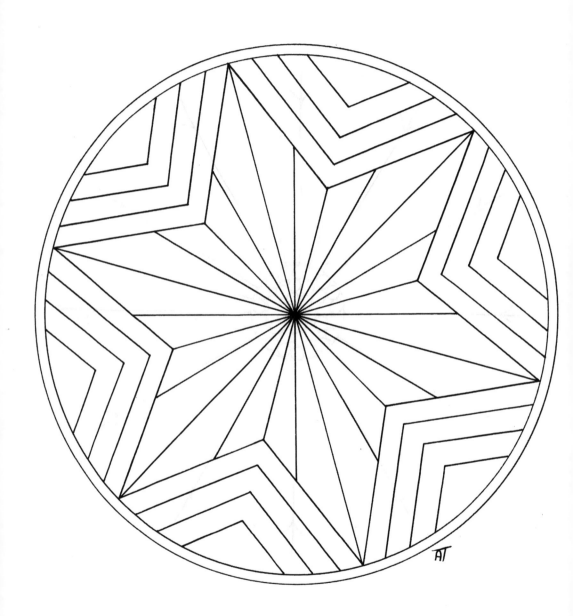

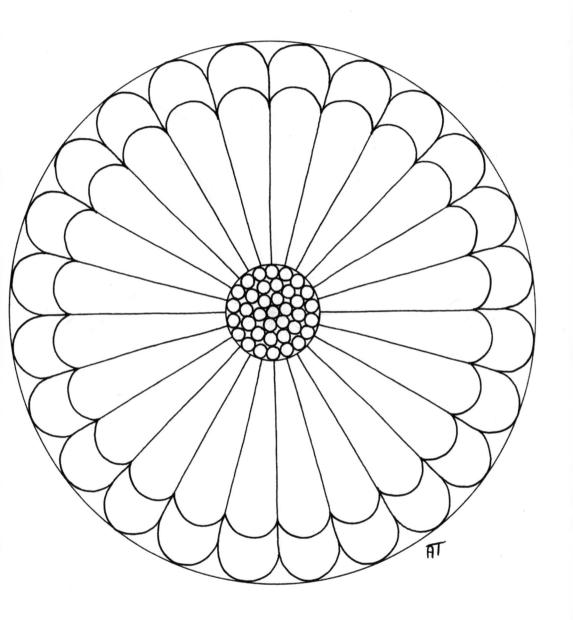

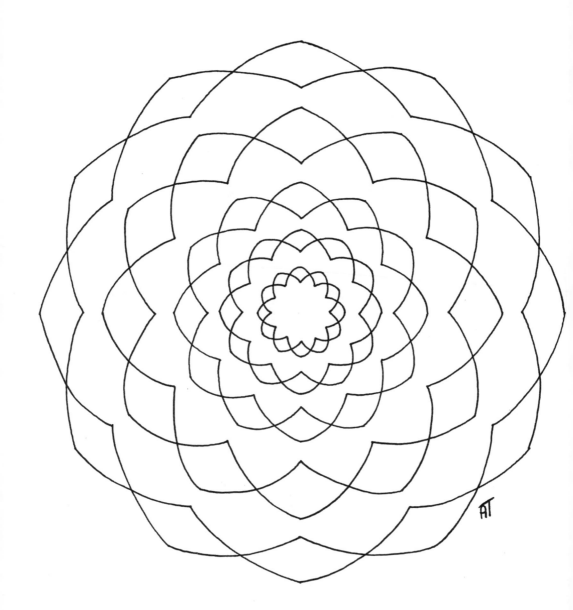

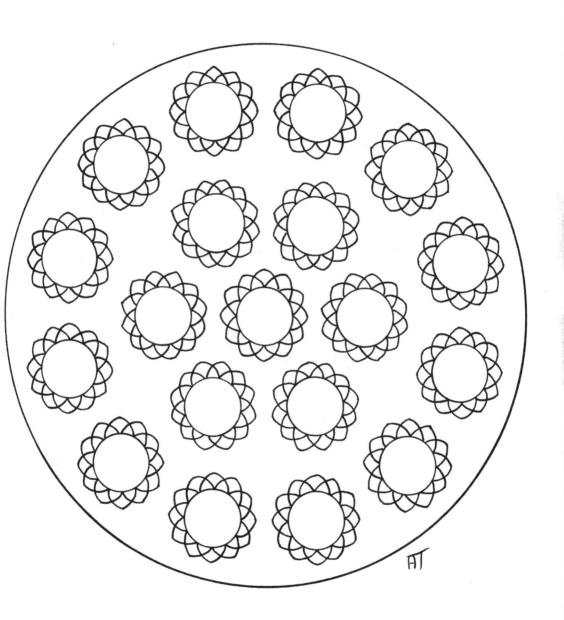

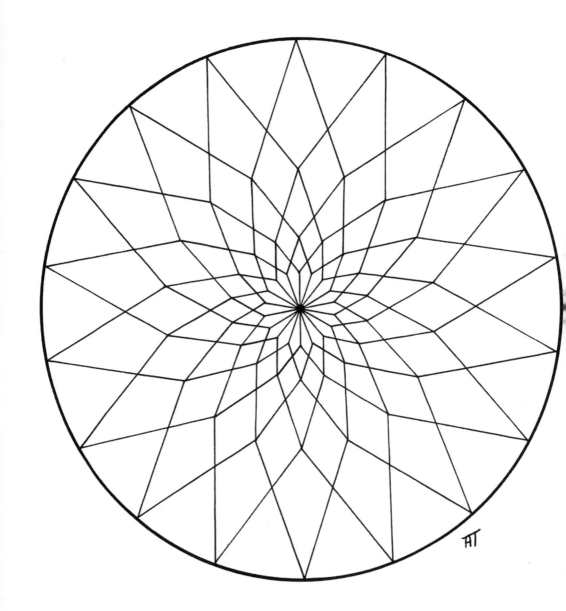

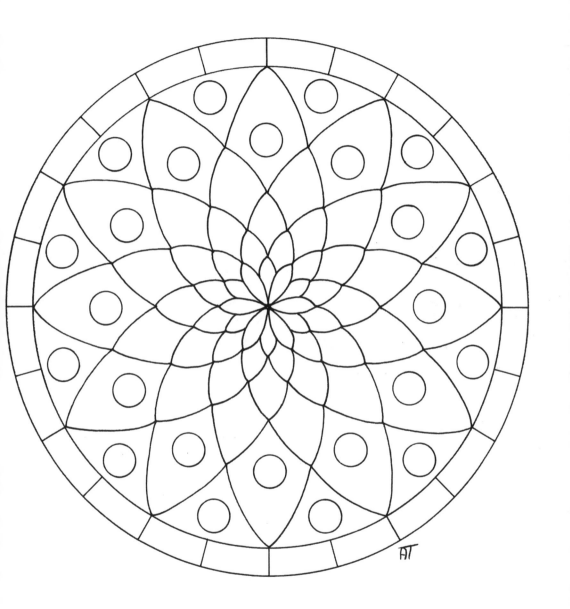

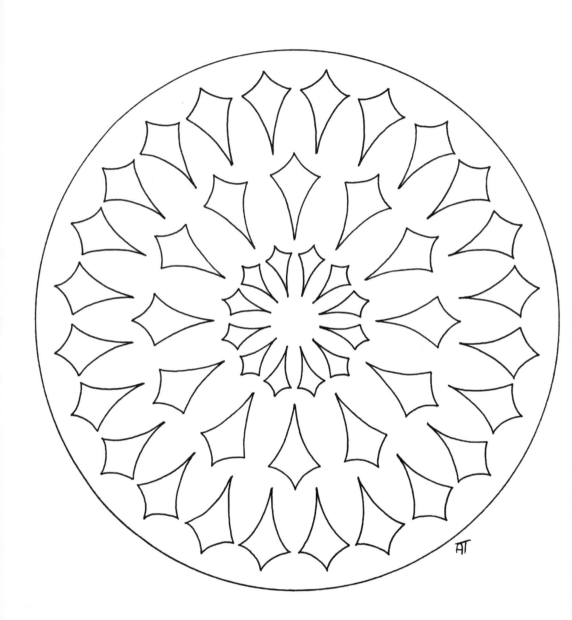

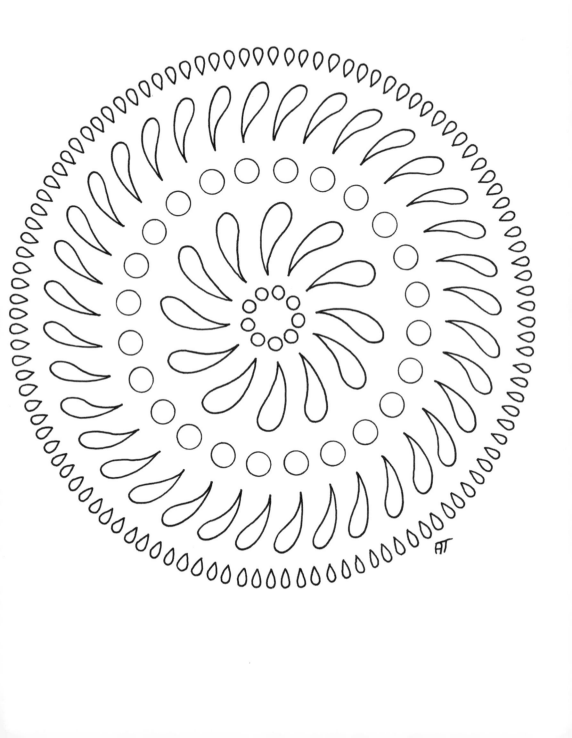

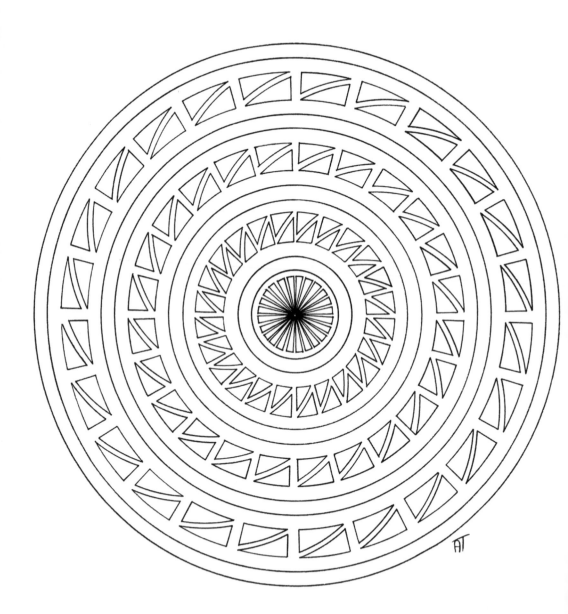

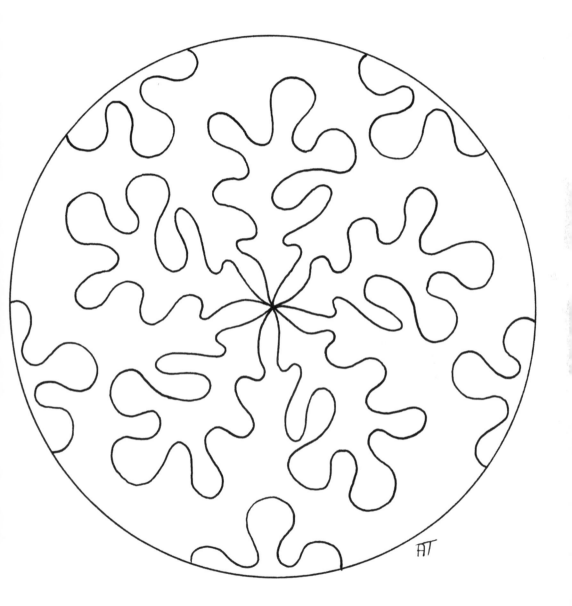

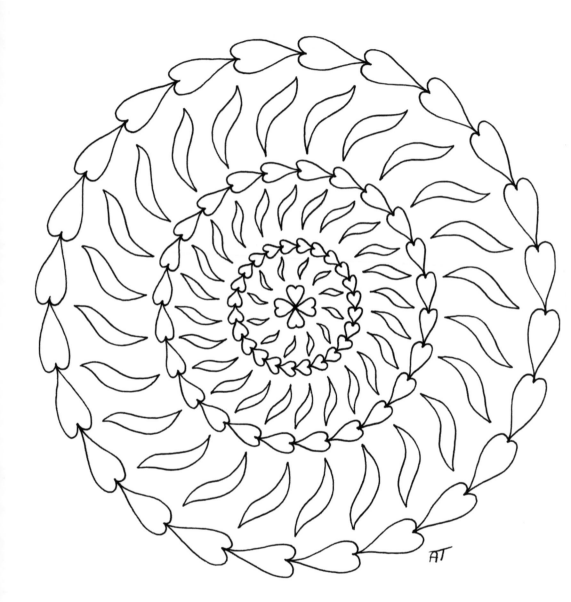

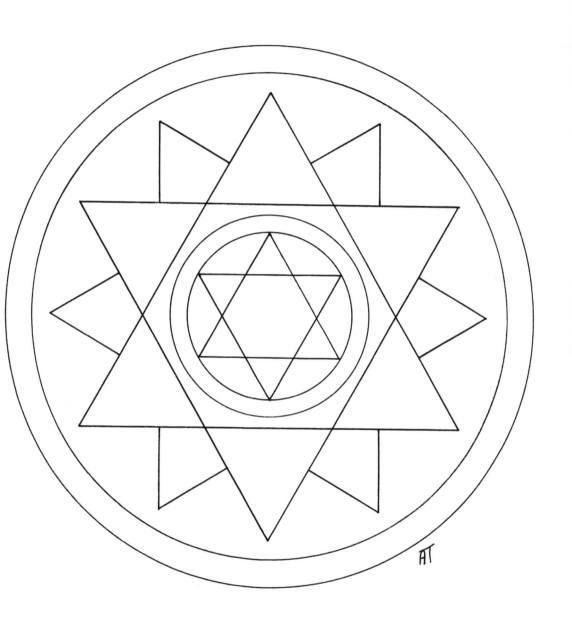

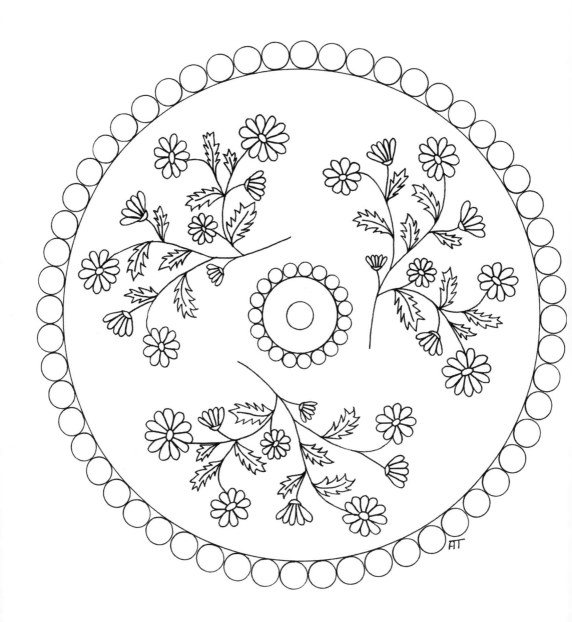

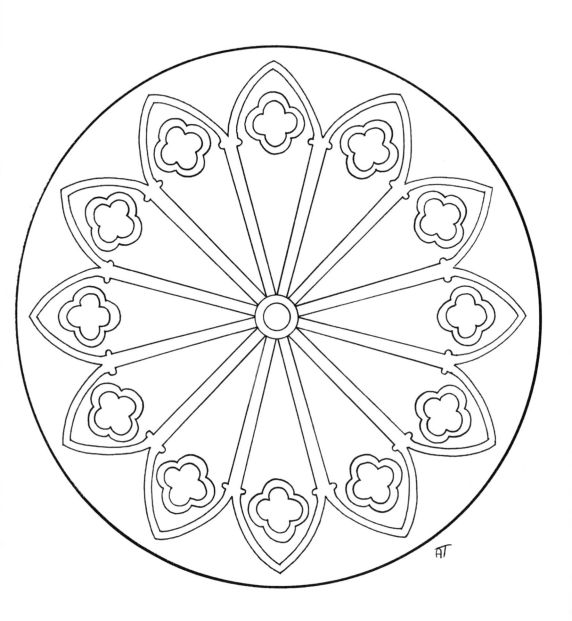

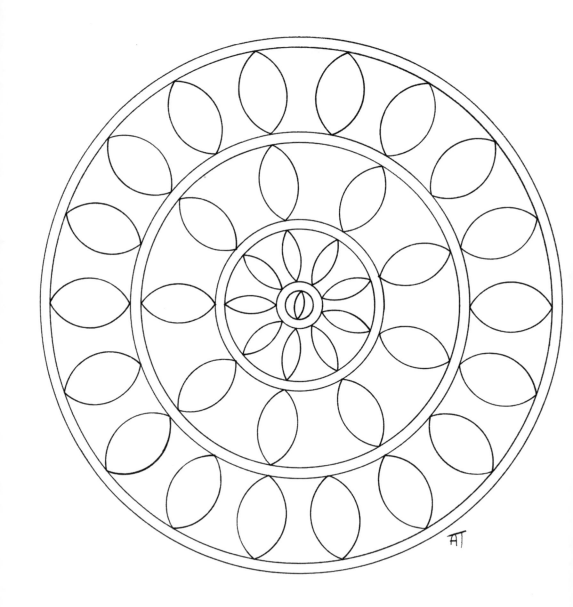

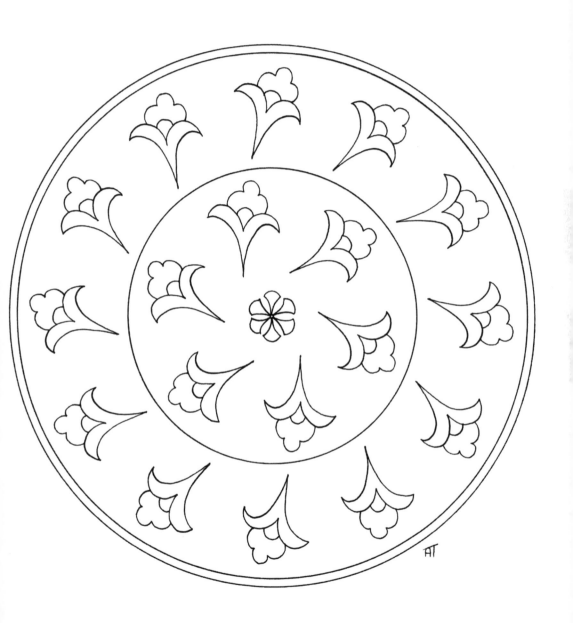

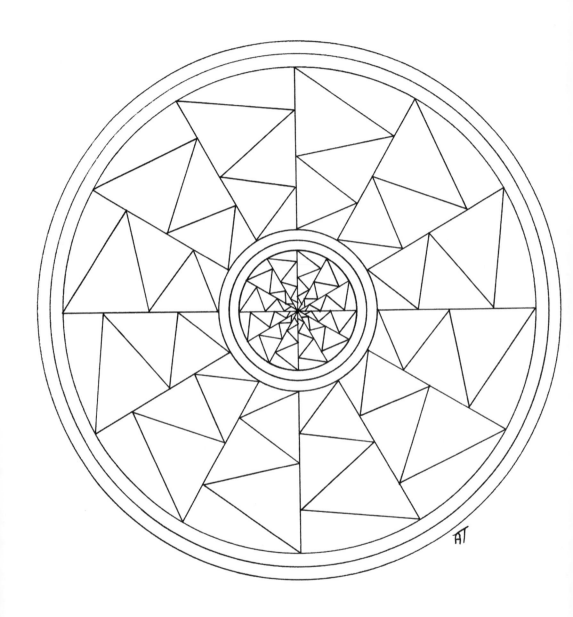

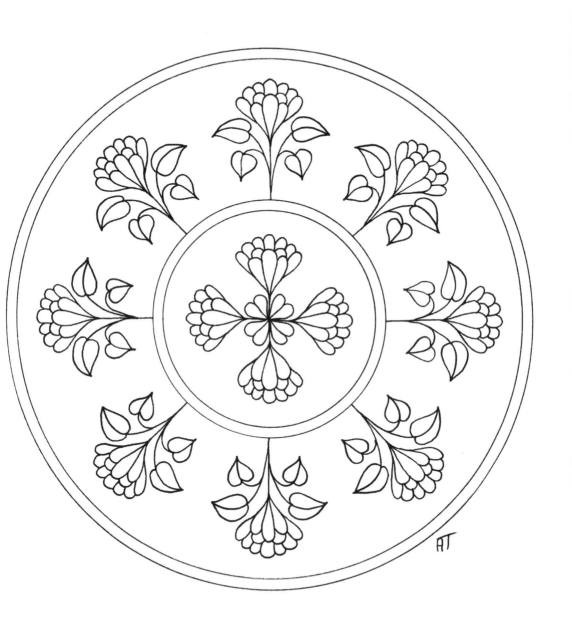

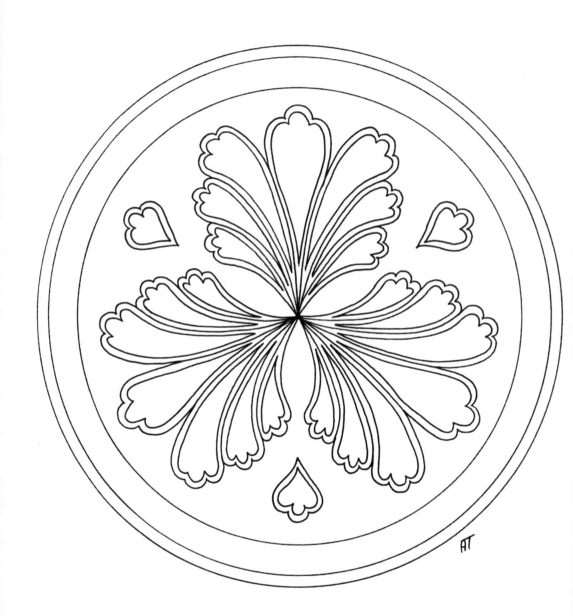

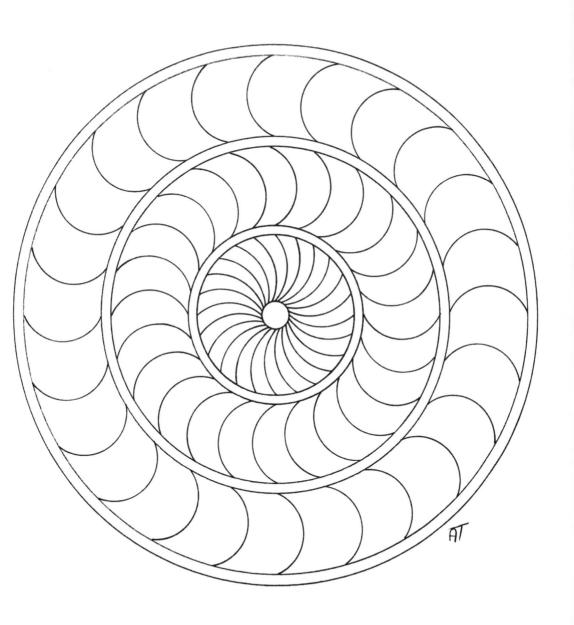

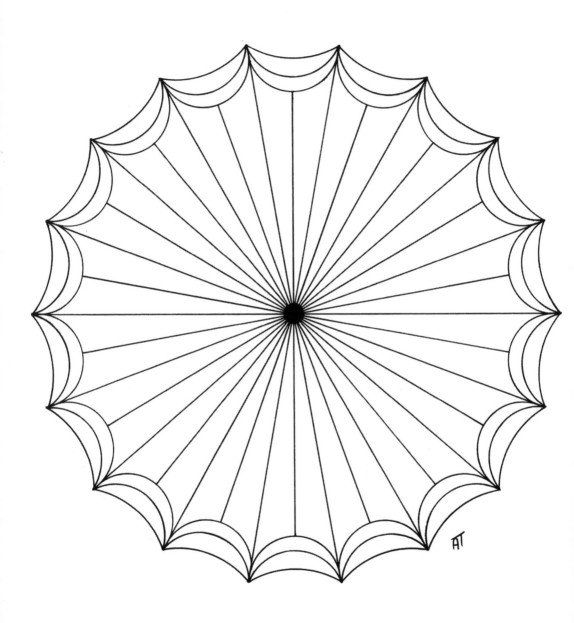

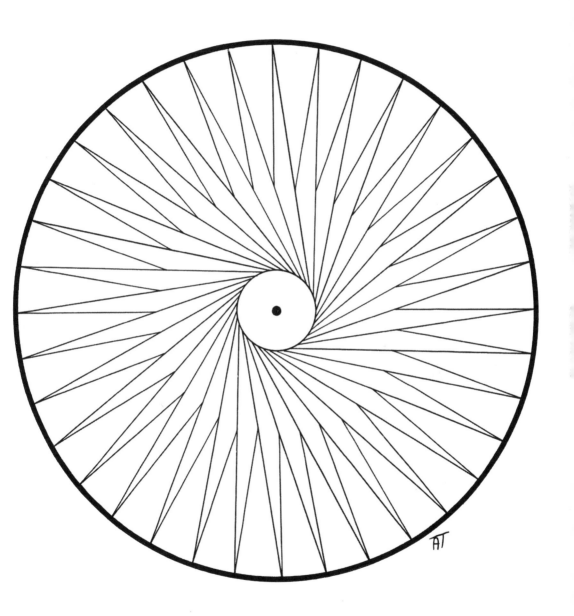

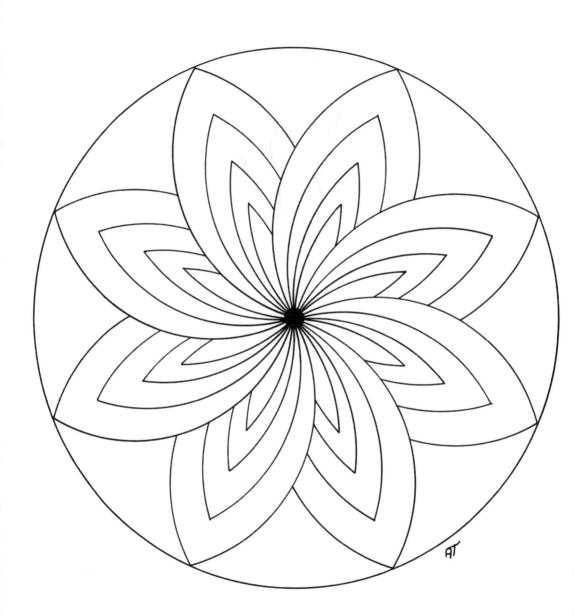

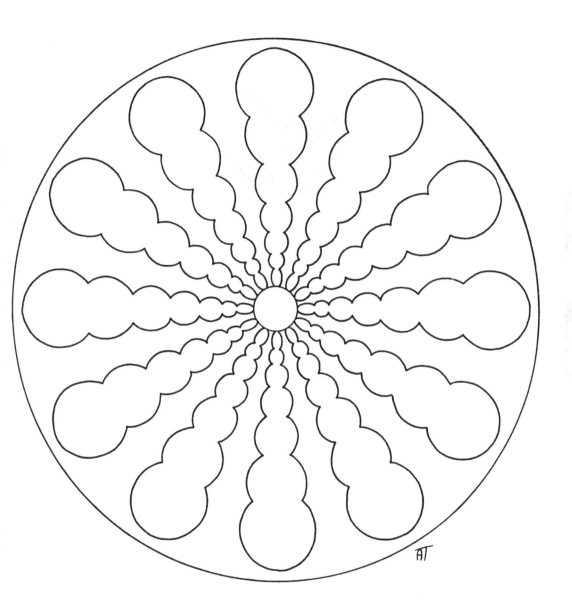

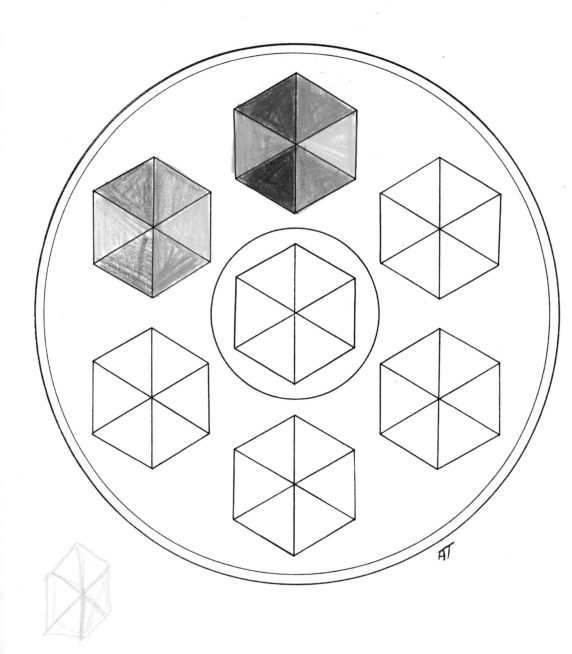

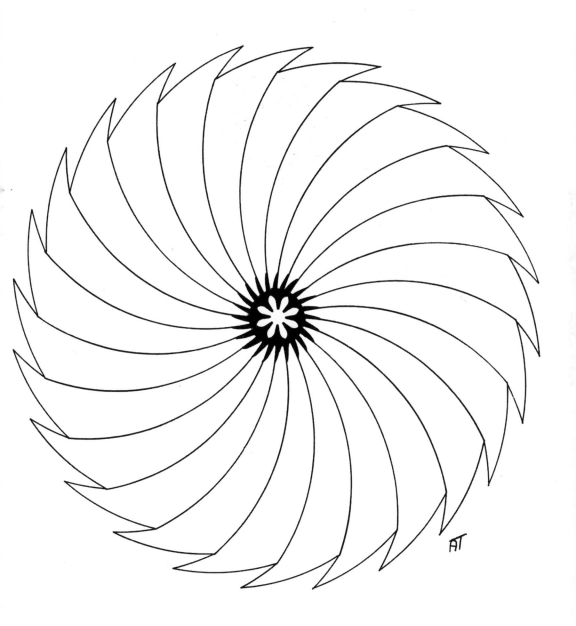